T0146822

WHISPERS
FROM THE
DEEP

OLADIJI WUSU

My Interpretation of Life Events Around Me

authorHOUSE®

AuthorHouse™
1663 Liberty Drive
Bloomington, IN 47403
www.authorhouse.com
Phone: 1 (800) 839-8640

Published by AuthorHouse 06/16/2016

ISBN: 978-1-5246-1468-3 (sc)
ISBN: 978-1-5246-1466-9 (hc)
ISBN: 978-1-5246-1467-6 (e)

Library of Congress Control Number: 2016909905

Print information available on the last page.

This book is printed on acid-free paper.

"To

ChooChooBooBooKataKataMayaMayaPuschPusch,

Three Roses: The Lamb, You and I"

This contains some of my thoughts :

...............on seemingly innocuous life events.

...............about my Alma Mater

...............on some heartfelt expressions of Love

THE TEMPEST

From the wake of dusk
To the somber of dawn
To his weary blade must he cling
Such the prince of destiny doth bring

Pitched in the midst of affable friends
Yet encompassed by implacable foes
A penny to spare so that all might end
Or more, than face the on-coming woes

Fighting and winning he surely must
As he voyages through the pearly portals
Till faded flesh sleeps as ductile dust
…such is the life of mortals

OH QUEEN

The growl of the town-crier so ominous
Lo the *Gangan* drums yelps unceasingly
The king yet requires a bride luscious.
Reverberating through all and sundry
Need to do the biddings of the taciturn potentate

Hang ye the harps cling to the sickles hideous
Wield the mighty cudgel unwittingly
Make subservient the white reluctant sandy jewel
Ceaseless blows bequeath to it assiduously
Till it recognize his suzerainty

Sound the trumpet loud and spurious
Draw the jaw-bridges haplessly
Enlarge the tent make it spacious
For the coy white bride ever so comely
..Oh Eba thy sight ever so regal

*Eba-A traditional dish in Nigeria made from Cassava flakes

THE SLEEPLESS SOLDIER

Before the wake of the cock
Before the stretching of the sun
I, the solitary sleepless soldier
Shall trudge in tired-less gait
To the sojourn of the money masters

The cacophonous chaotic accapella
Of the uncouth, paid bus-crier
A melody my feet finds so delectable,
I shall cow in the lungs of the beast
Only to be liberated by the magic words *'owa'*

The second-hand of the clock
and I share a bond unspoken
Announcing the daily sacrifice is accepted.
Dancing endlessly to tune of the money chasers
Till the turning of the globe spins no more

*Owa- an informal and local command to stop
a bus at one's preferred drop-off point

GOD BLESS MY ANCESTOR

I am angry with my ancestors,
With my progenitors I bear an eternal grudge,
But why is that so?
Is this not the land to flow with milk and honey?
Though I see rivers of tears and blood!
The hatchet lies elsewhere!

I am angry with my ancestors,
With my progenitors I bear an eternal grudge,
But why is that so?
Is this not a land where I should be the son of the soil?
Master of all I survey?
Yet I see men as slaves to the khaki overlords
The grouse lies elsewhere!

I am angry with my ancestors,
With my progenitors I bear an eternal grudge,
But why is that so?
Is this not the haven of deep values of integrity?
Though I see tri-faced masked men in power
My anguish lay elsewhere!

I am angry with my ancestors
With my progenitors I bear an eternal grudge,
I am angry that they lacked
the fortitude and foresight to board
Vile vessels of the slave's ships of success
To traverse the arduous Atlantic
To register our inheritance in 'paradise'.

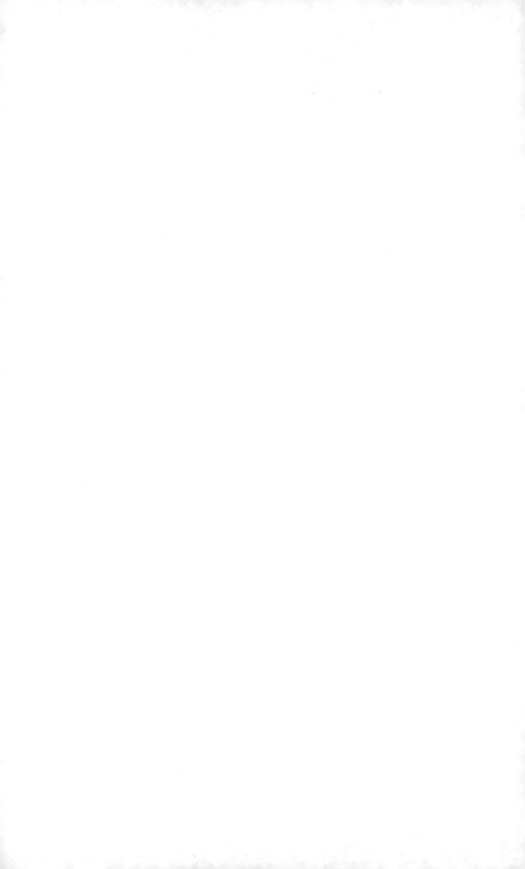

LOVE AT FIRST SIGHT

From the first day that I saw her pretty face
I knew she was going to be my next craze
Felt silly running after her
Cause she was gone in a jiffy
Down the dusty old road
One evening as I took a stroll
There she was with an old friend of mine
I said to myself 'wonders never really end'
I whispered into his ears
If you don't mind I'll like to take her on
He said be my guest because she's no more fun
I looked into her eyes, Cold as ice
Yet I knew she wanted me
So why waste time dilly dally

I promised her a jolly good ride
If only she will let me inside
As I stepped into her interior
I could feel her bodywork was superior
The way she carried on
She seemed to be asking for more
Since I wasn't ready to be outdone
I gave her some more
We twisted, we turned, we bumped
Her bumpers I did jostle
The more she screamed the more I hustle'
We went all the way
As Time held no sway.
Till it ran across my mind
Meme-My friend must be losing his mind
Waiting for me to return
Sighed to myself, 'here goes my test drive'
In his black and lovely Bmw x5

NO CHICKEN PLEASE!

What is the world turning to?
It started with this gist
They call it the 'Killer beans'
I said my byes to 'akara' and bean cakes!

Then they flashed my ears
A joke I thought, a joke it should be
Killer noodles were here
That gave me the hibbie-jibbie

As if that wasn't that bad
They said our cows have gone mad
So you tell me no more beef!
Yeah! tell it to the sheriff

Now what's making me craze
Is this bird flu case
No more turkey! No more chicken!
You must be kidding!
What is the world turning to!

MY WORLD

I shall change my wardrobe
every now and then, every then and now
I guess I must be special

I should be off to London
For the first semester holiday
I guess I must be special

I should be dressed only in 'Tm Lewin'
Announcing my arrival as a 'Big boy'
I guess I must be special

I should not be heard
Only to be seen once upon a time
I guess I must be special

I should never stoop so low
To be caught with the 'uncream' ones
I guess I must be special

I should rather walk alone
Than be found in the midst of uninitiated touts
After all not everybody can be a 'club' boy

*Club-Boy- Local parlance for an exclusive fraternity on campus.

ACCESS ROAD

Next Of Kin to the capricious chameleon,
The access road is a marvel unsung.
Restrained, contained under daylight,
A serene, somber pathway even for the recluse.
Yet, at night, it dons the colours of the boulevard, most desired

As the poison of dusk spreads
It calls the Frenzied juvenile spirits,
In Hordes of unbridled steel horses,
Daring the surreptitious spoilers.
They Prowl the short-sized alley at a ferocious *frolicking* speed,

Oblivious to their testy tantrums
Is a rendezvous of hormone-charged colony
Hands-in-hands, mouth-to-mouth
As brief and innate intentions
Communicated with deep passions.
Such the daily tokens, The two-faced animals has to offer.

ENTER MY WORLD

My breath you took away
My heart you did still
making me want for what to say
shattering even my fortress-my will.

Entranced by your beauty
Bound by the chains of your grace
Marveling at your face my sacred duty
Speechless I was as I took a gaze

By your elegance, poise I was mesmerized
My blood froze like on a cold winter night
Even as in an inferno of passion I was engulfed
All evaporated; my strength and might

Feelings that cannot be uttered
Passions defying spoken word.
A myriad of thoughts
Through my mind floundered.
I wistfully wish you'll enter my world.

ACCOMMODATION LIST

Pooled to an ever-tightening radius
A sea of upturned heads dance.
"Excuse-me", "abeg- shift"" have you seen it?"
Such symphony rendered intermittently!

Additional mutterings of dissent;
"oh it was Moremi I wanted".
With swift slashing of the pen
They obliterate the once-sought nuggets
With sighs of "Thank GOD my name is out"

Others in despondent displeasure,
Offer a half-baked prayer
Maybe in the next accommodation list
My name will be there!

MOBILE PHONE-BOOTHS

At the base of "Obe rock"
Underneath the green dwarfing giants,
Lies the lair of the stalking predators
In desperate attempt to make eye-contacts
As every passer-by is a cow to be milked.

Neither age nor gender poses a deterrent
To their husky cries of "fone Kull?"
With unabashed braggadocio
And In muffled slithering hisses
They vaunt their tool of trade,
Unfazed by the sentiments of the men in blue

A mere nod in acquiescence
To their ever grinding question,
Spurs an avalanche of ever-ready
Mobile mammalian phone booth
Turning into disarray their guard of honour.

MY PROFESSEUR

In vain I cast chains
To bridle my untamed mind
In pains I set boundaries
To restrain my itinerant imaginations

In silent subservience sneers,
I cower to the pontifical proselyte
While Drawn ready my immaculate sword
Etching out the golden nuggets
On parchments of plain papyrus.

With Flaying hands, articulated gestures
He strives to initiate my virgin soul
In humdrum mutterings of restrained restiveness
I hold my fragile threads of peace,
Till the dulcet beep of his wristwatch
Announces the overthrow of the despot's tenure/regime

THE JAMBITES HAVE ARRIVED

Beneath the garnished mask of valor
Lies an effigy of broken dreams and egos
I console my battered and bruised self
That a star is never recognized till it is dusk
Surely someday, somehow, homage will be paid
To my immaculate imperial ego.

I n vain I watch with impudence
The plunder of the apportioned maidens
Too big for me, they say
Too small for them, they think
Courted by matured emperors and kings
Not a pitiful glance to our convoluted carcasses.

Alas they call when the projects and term papers knock
But not more than the required mere courtesy
Alas the fresher's list is out
A rumpus unspoken, excitement undefined
In pleasant agony I willingly wait
For the coronation of the puerile princess

Not a sight more to the weary game birds
As a gamut of opportunities lie in my lips
All I seem to hear is
A callous concerted cacophony
"You don't even talk to us anymore
Now that 'jambites' are here!

WHO AM I?

I live in three worlds;
A world of the 'UME' students
Who in a fierce fight won their place,
Among the shimmering stars

A world of 'Direct entry' students
Who conquered the thorny paths of polytechnics
To sit among the gods.

A world of dauphins; diploma students
Who trampled the scorpions of money and parties
To stand among princes

Who am I in these?
Three conduits, three parallels, three worlds
Never to meet, never to separate, never to join
Three worlds of wonders, three worlds of wars
who am I?

THE CAFETERIA

We shall gather,
in slated trickles
when the task masters,
when the pedantic overlords,
have no need of us
for yet a little while

we shall gather,
in fragmented grouping,
at the call of gangan drums,
louder, louder and louder
they assume painful dimensions
we no longer can ignore,

we shall gather,
in the concrete belly,
through the hostile seas,
we must have crossed,
and the barricaded booths
we must have breached.

we shall gather,
in tandem to their query,
when the Delphic oracle
contemptuously hand out,
the life savers heaped,
on batten of steel or plastic
to satisfy our hungered soul.

EVERYTHING IS YOU

The reason to go on
no matter who is in the race
the reason not to quit at dawn
till the end of the race

The strength to fight
till the battle is won
even in the darkest night
till my fears are gone

The very air I breathe
the element of my survival
why I never drift
you've got no rival

more precious than gold
more priceless than diamond can be
your worth I truly uphold
as the best thing ascribed to me

when it is so difficult to say
if I would make it through the day
you come and show me the way
and you make me bright and gay

WHAT PEDIGREE?

I've met other princesses
I've been with other royalties
I have scolded gracious ladies
I've acquainted with geniuses
I've known great achievers
I've chatted with beauty queens
I've dined with angels
....Yet I'm mesmerized and I marvel every time I'm with you

BETRAYAL

Like a golden dagger to my soul
Like diamond sword across my soul
Like whips of emerald over my back
A pain I have to endure
A pain yet so hard to bear
A war not to be fought
A battle not to be lost
torn between two passions
haunted by two emotions
my mind is saying Hate Hate
my heart is saying Love Love
my mind wants to strike back
my heart wants to sit back

Like molten fire it burns
yet it can't be contained
Like rushing water it runs
yet it has no form
Like a shadow ever there
yet unbecoming to my clasps
Like the whistling wind it blows
yet without a character
bitter elements of life, the forces of death
vital elements of love, powers of hate
Kindled aflame withering till it burns
the scale is found wanting
yea the line has been drawn
the sword of Damocles surely you must draw
As the wheel of fate turns without repentance.
Yes times your heart must fight
not you want to
but you've got to

YOU ARE SO DEAR..

I'll cross the deep blue sea
I will climb the mountain peaks
I'll give you the sun and stars
I'll grope through the deep and dark valley
...Just to show you that you are truly "DEAR"

I FEEL FOR YOU

Beyond description
Defying definition
Superseding explanation
Incomprehensible to logical resolution
Aside mortal comprehension
Defying nature's compulsion
...Is what I feel for you

I WILL DO IT ALL FOR YOU

I'll fight the forces of death
confront the powers-that-be
defy the ordinances of life
challenge the authority that do reign
churn the elements of existence
...I'll do it all for you

From the cracking of the dawn
to the setting of the sun
from the silver moon's advent
till when the night is far spent
I'll be yours you'll need never despair
We'll forever be together

THROUGH ALL

When the night seems so cold
and it seems I'm destined for a fall
When there's nothing to uphold
....it's your sweet loving thoughts that gets me through all

When the time seems cruel
and it seems I've lost my song
When it seems I'm losing in the duel
....it's your sweet soothing words that makes me strong

When the battle becomes so fierce
and it seems I'm fighting in vain
When it seems I'm left with my greatest fear
....It's your sweet endearing comfort that keeps me sane

When the world seems so callous
and it seems I'm on the path OF the loser
When it seems all is unsteady and in chaos
....It's your sweet charming memories that make me a winner.

Forever In Your Heart

Wherever you may be
Wherever you may go
If I am still me
and all I said be so
Then know this:
You will forever have a place in my heart

For you I will.........
Bend till I break
Burn till I'm gone
Give till I am spent
Comfort till I am flat
Care till I'm no more there
Love till I'm no more

No concrete evidence but yet
nothing disproves the validity the truth
That you are dear so precious to my heart
And by intuition I know
our paths will surely cross again
hopefully forever

FOR YOU I WILL

For You.......
I will swim the seven seas
I will get you the moon
I will stand surer than the trees
As you call it will be that soon.

I will give you the sun
I will add the stars in the sky
I will give you the world even as it turns
It will be yours even if I have to fly.

I will bend till I break
I will fight till the end
I will stay even if the earth shakes
As my love for you has no end.

EVEN IF... AND I COULD... I WOULD.

The red rose blossoms and withers
The lily in the valley blooms and die
nothing ever so sporadic as the weather
Yet my love for you will never die

The sun sets and will be no more
The clouds will surely break away
even if life seems so sure
Yet my affections for you will never go astray.

The night may seem dark and long
The days may be lonely and still
Even if all seems to go wrong
Yet my feelings for you will always be real

The rain may cease to fall
The times might seem cruel and untrue
even if life seems meaningless and dull
Yet my heart will always go out to you

The wind blows without direction
The storms will not always be there
even if I am through with emotions
Yet to my heart you'll always remain dear

The seasons will not last forever
The storms will surely rage
even though nothing seems to last forever
Yet my love for you definitely will never age

The stars may stop being blue
The nights may seem callous and cruel
Even if life has no value
Yet to my soul you will be the most precious jewel

The rainbows may lose their color
The trees may lack roots and stem
even if life was void of honor /men of valor
Yet to my being you will be my priceless gem.

GIVING MYSELF

I am not promising you the world
But I'll give you my all in TOTALITY
I am not promising you heaven on earth
But I'll give you my best in SIMPLICITY
I am not promising you a noble prince
But I will give you myself in SINCERITY.
`````

# What Is The Meaning?

Truly a molten fire it burns
never a dynamite
slowly but surely
frivolously but firmly
Are my affections for you.
I said I didn't care
I meant I was scared
I said I hated you
I meant fate was untrue
I said I was tired of you
I meant with life I was through
I said I wanted you out of my life
I meant that was the end of my life
I said you didn't mean a thing to me
I meant life had no meaning to me.

# YOU AND ME

Clouds without rain
Smoke without fire
shadow without a person
That's life without you!

Nature sanctions our duality
Ordinances of life plotted our relationship
Forces of life grafted our coupling
Fate consented to our union
Destiny assented to our coalition
Powers-that-be decreed that we be
The deity authorized our matrimony.

# IT IS YOU

On the canvasses of my heart
Astride my dreams and my imagination
Indelibly and discreetly etched
Is your "NAME"

On the tablets of my soul
Transcending my hopes and my ambition
Boldly carved emphatically
Is "YOU"

The only love song
The only melody
The only ode
The only epigram
The only name I'll call
The only medley I will orchestrate
The only opus I'll write
is "YOU."

# My Delight

Through cold and chilly nights
When the stars gray and bleak
It's your words that bring me delight
Ensuring my soul isn't weak

Through the dark and somber skies
When the clouds are wet and saturnine
It's the warmth in your eyes
That bring a kind of comfort I cannot define.

# THROUGH IT ALL

The rain-clouds rants and puffs
The thunderstorm looms in full blooms
Meandering unleashing it's terror in no double bluffs
Yet the eagles know as the bride knows her groom
Beyond the canvasses of darkness
Astride the canopies of chaos
Unruffled by the tantrums of the storms below
Concretely situated abounding in bliss
Through the darkness and it's paraphernalia
Over the broad horizon lies the sun
You're my trusted friend on
Whom I can depend on?
Through all.

# OWE ALL TO YOU

I saw life as cruel and bitter
void of joy and gladness
I thought it could hold nothing better
than sheer gladness

The colors of the tines were pale and sad
drapes of desolate loneliness
it seems it will always be bad
a situation of utter hopelessness

Till the sun shone leaving no trace
as it dispels all the fret and fear
it's warming embers set my heart ablaze
The sun in the dark sky is you my dear.

# YOUR LOVE

Your love so true and pristine
More than I can define
Your love so sure and primordial
More than any friendship so cordial
Your love so pure and primeval
More than any rival

Powers-that-be do rule
Forces of life still reign
Homage are paid to kings
Tributes are bequeathed to queens
Lofty and high are the hands that wield the strength
calling forth things to be and not
Wheel of life turns as it wills
All I can hope is that
We will always be together someday.

# TILL I FOUND YOU

Life was like a prison
A place of sorrow and tears
Till I met while I was in prison
...It became a place of joy void of fears.

Life was like a grave-site
A place of gloom and sadness
Till you came within my sight
...It became a cradle of fun void of madness.

Life was like a valley
A of fret and strife
Till I met you as a darling
...It became a mountain of hope and a beacon of life.

Life was like a desert deserted
A place of rejection and loneliness
Till we got acquainted
...It became an oasis of love and happiness.

Life was like a lonely Island
A place of pity and dread
Till we got hand in hand
...It became a paradise of comfort unheard.

Life was like a fiery Hell
A place of sorrow and death
Till we got bound like spell
...It became a Heaven of glory and a mine of wealth

Tell it on the mountain
Let it be known on the hills
Tell it on the rooftops
Let it be known in the neighborhood
Tell it every ear
Let it be no stranger to every heart
That my affection is given to no other

# On My Mind

I wish I could say more
I wish I could always be there
I wish I could do much more
Yet to my heart you will always be dear.

The wind blows as it wills
The waves tosses to and fro as it dims fit
Life's like a shadow
Truly there yet unbecoming to reach
Yet through all you are strongly on my mind.

# The Rainbow

Colors of the rainbows
Spell out your Name
The patters of the raindrops
Is a medley of your Person
The patterns of the dark clouds
Reminisce and carve out your Being
The rays of the glaring sunshine
Reflects the charms of your Face
The whistling of the wind
A melody of your heart.

Diamond becomes worthless
Gold is rather banal
Rubies are like rubbles of stone
Silver becomes a jettison
Emerald is stripped of it's radiance and beauty
Jasmine becomes a non-entity
Pearls are deprived of their glitz and glamour
...When compared to you!

# An Ocean

An ocean deep and wide
An ocean warm and lively
An ocean pure and true
An ocean I'll rather drown than stay afloat
An ocean I won't fight for life s
An ocean I'm willing to give up to
...........That's the ocean of your love!

# BEING WITHOUT YOU.

To face the bitter cold is inconsequential
To meet a hungry lion wanting for food is trivial
To meet a bear robbed of her cubs is no big deal
To face a thousand foes blood thirsty is a piece of cake
To walk through a raging inferno nothing but a dismal task
To wade through a torrential flood is nothing but a child's play
.......But I cannot handle being without you.
A deathly still creeps over the night
Shadows of evil unfold their wings
A cohort of darkness their terror
Fear and fret assumes the order of the day
Yet you're my Darling Gem
for whom no price is too great to pay

`

# I Can Rely On You

At the drawing of the curtains on the thresholds of life
A drama of fear and passion
Beads of terror cascade down the spine
Divulging the intents of the hearts
Yet you are my trusted friend on whom
I can depend on.

# MY CROWN

When I'm feeling so down
And cannot go the extra mile
You take away the frown
And put on me a Smile

When I am feeling so down blue
And seem I am going to drown
Just thinking of You
Puts on my head a Crown.

# Living Without You

If living is without you
Then I will rather die
If breathing is you not there
then I'll rather want for air
If loving you is a crime
then I'll always be an incorrigible outlaw
....Cos I cannot be without you!

# I'm Looking At You

Looking into your Eyes
The portals of the life beyond
A world untouched lies behind
A haven of rest
A fortress of strength
An uncompromising defense
A tower of warmth and acceptance

Looking at your Lips
The sentry to the apotheosis of paradise
The quintessence of a world wished for
A palace of solace
A castle of comfort
A fountain of hope and life
A bed of roses amongst thorns
It's nectar the elixir to the hurts of the day!

# MY DARLING

As I lay alone
at home on my own
My thoughts keep going astray
Just on one way
....The path leading to you only!

I tried hard
to be on my guard
to control my thoughts
But no matter how hard I fought
.....You are all I think and wish for!

Thinking of you
Put in me a smile that's true
A joy difficult to explain
A force I cannot contain
....Thank you my darling!

# The Embrace

When I look into your eyes
I am one step into paradise
An embrace with you
is an embrace with life
When I am in your hands
Heaven is just a wish away
A kiss from you truly
is a kiss of life from the stars

With every breath I take
With every tear that is true
With every beat my heart makes
......My heart desire is to always be with you!

The hours seem longer
and the seconds seem like days
Time isn't growing any younger
.....Yet I am missing you in every way.

# Where Are You?

I am here
and you are there
This is also true
That I still love you!

When I think of you
You bring a kind of joy
difficult to explain but true
no matters the words I employ

I am so happy, Yet I am sad
I feel so good, Yet I feel so bad
Why my dear?
It's because you are not here!

# My Red Wine

Like the exotic red wine
You are quixotic and fine
Like the exquisite purple grapes
You are my queen of shapes.

My heart to thine heart
I give to be joined as one
Beating forever as one heart
Even when the sun is gone

As I sink into the miry clay
And think I will not see the light of day
You show the way
That you are the one that makes me bright and gay.

# THINKING OF YOU

Diamond and gold are what
most people think of all the time
Wealth and power are what
others will give their last dime
but you are what
is preponderant on my mind.
In my saddest moments
When I cannot even comment
Thinking of you
brings a joy so true.

# JUST FOR YOU

Day after day
Night after night
Hour after hour
Minute after minute
My wants keep changing
My needs are never the same
My passions takes a turn
...But my one constant desire is You!

A road so narrow and rough
A path difficult to tread
A road even dangerous for the tough
Yet a path I will gladly tread
..............Just for you!

# ALONE WITH YOU

There comes a time
When time ceases to exist
When hours are nothing
but mere moments
When seasons
become like seconds
When years
are referred to as days
When weeks
go by in a twinkle
....When I am alone with you!

# THE MELODY IN MY HEART

Whenever I think of you
You are the fire in my eyes
The sun in the skies
The soothing balm to my soul
is your enchanting voice

Like the tolling of the Christmas bell
Your name rings in my head
Like the chimes of the jingles
Your name a melody to my heart
Like the picturesque sight of the snow
Your face blends into my soul.

# Let Me Dance With You

Fly me to the moon
♥      let me play with the stars
Without you I can't be content

Give me the sun
let the universe conform to my whims
Without you their is no appeal

Show me the light
let creation pay obeisance to my wish
Without you their is no pleasure in life

Take me to heaven
and let me dine with the angels
Without you all is a mere frivolity.

# A Fool For You

Most people call me crazy
Some think a fool of me
Others tell-tale that I'm insane
While The rest brand me derailed /deranged
I can't comprehend what they mean by these
All I know is this
I am simply a fanatic for the one that loves me.

Your breath holds my universe in focus
Your smile the very foundation my soul rest on
Your laughter the remedy for my every malady
Your voice the eternal incentive to go on

# I STILL HAVE YOU

If they strip me of my wealth
♥    .........I'll only be richer
If they take away from me power
.........I'll only be be stronger
If they withhold from me knowledge
.........I'll only be wiser
If they deny me of having friends
.........I'll only be happier
If they hinder me from dreaming
.........I'll only be be richer
...............Cos I still have you
and will always have you

# WHISPER INTO MY HEART

Whisper into my heart
Whisper love into my heart
Breathe into my life
Breathe joy into my life
Speak into my being
Speak comfort into my being.
Displaced by chance
Separated by time
Displaced by chance
Yet you mean more than every dime.

# You Are Here?

I did not know how much you meant to me
Till you were not with me
I did not know how much I cared deep inside
Till you were not by my side
I did not know my feeling so sure
Till I did see you no more
I did not trust the feelings that we both did share
Till you were not there
I didn't see how much you cared
Till you were no more here.

# My Angel

♥        On a cold rainy day
Starring out through my window pane
Wondering why things were in disarray
Without you life is fraught with pains

Pondering at the cold outside
There is warmth only in your arms
Safe and sure when I am inside
Knowing unto me can come no harm.

Peace to you angel in the night
that brought me glad tidings
You gave me a song of song
And put laughter in my heart
You wiped away the tears from my eyes

Oh sweet angel, Angel of light
Joy and life are at your bidding
You held me close and made me strong
And you gave me gold for a heart
You told me I could fly and my home was the skies.

Alas my precious angel, Angel full of might
My soul is at rest, my heart is gladdened
Since you made right all the wrong
my heart is joined to thine heart
You and I will be together even if time dies.

# I KNOW WHAT I KNOW

I don't know why the sky is blue
but I know I love you
I do not know why the sun is so bright
But I know I find in you sweet delight
I do not know why the rain falls
But I know I am willing to give you my all
I do not know why the wind blows
but I know my affections for you grows
I don't know why the stars glitters
But I know life without you is bitter.

# MY JEWEL

Oh shining stars
♥      In the deep dark night
Shining from afar
Bringing hope with your light

oh my precious jewel
Into my soul I will keep you deeper
I know all will be well
As my wish is We will be one forever

# A Moment...

A moment I wish
A moment so true
A moment I'll cherish
A moment with you

A moment of gold
A moment of priceless value
A moment that will never grow old
The moment I share with you.

A moment without you
is like an Eternity in the dark
Forever with you
is a mere moment I wish never to pass.

To find another angel like you
will take forever
and I have not gotten that long to stay
Will you be mine forever

# The Shadow

As the West is engulfed by the tentacles of the East
When the North and South are blood brothers
As the sun and moon rise & fall with one will
When light and darkness have everything in common
.....then to my heart can you be a mere shadow

# IT'S BECAUSE OF YOU

Pitter Patter! Pitter Patter!
♥      Such sound filled my heart
Clouding my innermost thoughts
without measure beyond imagination
it pounds defying all will
could it be the sound of the rain
...No it's tears from my eyes
because you're not here

Give me the shimmering moon
I'll give you the dazzling sun
Give me the world as it is
I'll give you the universe As you wish
Give me the frowning clouds
I'll give you the night clad with stars
Hold my hand and show me the way
I'll give you wings and make you fly away

Let the ancient boundaries tumble
Let the pillars of truth be crushed
Let the foundations of life
Let the ordinances of creation be defied
Let the powers-that-be crumble and fall
......just call on me
I will answer as you call

The foundations of truth may be shaken
The pillars of the sky may be crumbled
The dazzle of the sun may be annihilated
The glitter of the stars may be stalled
The lining of the clouds may be stripped
The shimmering of the moon may be made void
.....Yet you will remain dear to my soul.

# OASIS OF LOVE

Drifting through the ocean of life
Without a captain
Nothing did life offer but strife
Till I found you a joy I can't contain

Wandering to the maze of destiny
Without a wish to live
Lost and confounded without a penny
Till I found you a reason to live

meandering through the dessert
Famished basking in the pool of dearth
Till I found you my oasis, love of my heart

# Because I Love You

Taking away your pains
And giving you paradise
that's my wish

Taking away your fears
And giving you courage
that's my desire

Taking away your hurts
and giving you gladness
That's my duty

Taking away your weakness
and making you strong
That's what I always want to do.

Taking away from you nothing
And giving you my everything
that's because I love you

# MY WORLD

Ask for the resplendent shining cloud
I'll give you the Iridescent rainbow in the sky
Covet the quiet somber night
I'll bequeath to you the night clad
with the sparkling diamond star
Desire the glistening silver moon
I'll deliver to you the Incandescent glowing sun
Long for a moment with me
I'll bestow to you my lifetime
Demand for my substance
I'll yield my all to you
Crave for the tangibility of my world
I will give you the totality of my universe!
``

# GIVE ME AN ETERNITY

If I had an eternity to live
I would spend only a moment of it without you
If I had forever to stay
I would spend my existence with you
If the power of night and day were mine
I would spend all the days with you
If I had the world to give
The universe would be yours
.............To my heart I pledge
You will always remain dear.

# All For You

With my arms
I'll protect you from all harms
With my heart
I'll guide your heart
With my life
I will shield you.

I'll winnow the sands of the desert
I'll churn the waters of the ocean
I'll set ablaze the moon
I'll darken the sun
To fold the up the fabric of the sky
........All for you.

# I Am Free

Set me free
As you bind me with the chains of your love
Keep me afloat
As you drown me in the ocean of your love
Fill me
As you stir in me the hunger for you love
Tie me down
As I soar with the wings of your love
Give me life as bury me in your love.

# THE GOLDEN SUN

Oh golden sun in the sky
I the morning dew evaporate into your arms
Ah the silver moon in the dark treacherous night
I the pearls of raindrop irridescent in your light

# I'm Running To You

I know a place where I can hide
safe from all perils
I know a refuge where I can be
Abounding in incomprehensible bliss
I know a haven where I can lodge
Secured in the culminate/paragon of peace
Father I run into your arms
Wipe away my tears
Show me that you care
Keep me safe from harm as I run into your arms

# MY TENDER ROSE

I will suffer not your petals to be plucked
My life I'll lay down as a ransom
No harm will come to your budding
My breath I will down as a surety
No bruise, no pains too much to bear
A promise I'm staking my substance for
upon the pristine rocks of ancient time
I'll plant your footing/footage strong and secure

# ARE YOU THERE?

let me hold the power of your heart
So I can rest safe in the arms of love
let me feel the warmth of your embrace
So I can have a reason to live
Let me hear the sonority of your love
And know that you will always care
Let me touch you
And know that you are real

# I'm Dancing With You

King of the dance floor
my heralding niche to the dance floor
smoother than the dripping honey
straight from the honeycomb
gentle as the glistening moon over the sleeping horizon
So graceful in my stride
The lion never a contender
Resplendent in my plumage
dwarfing the peacocks genre
.........lo and behold never to don my dancing shoes again
If I won't be dancing with you

# NOTHING LASTS FOREVER

The mountains surely will disappear
The oceans will someday dry up
The hills will be made straight
The valleys will be no more
Time will perish
Life will be accentuated/terminated
...Yet as long as I be
You'll always be dear to my heart

# I STILL CARE

At the setting of the dawn
when the fervor of youth is gone
and is just the two of us that are there
you'll never need to ask if I still care

I turn to the East
I see you in the West
I face the North
I'm with you in the South
Even though you are not here
In my heart you will always with me.